D0478297

Nikon Guide to Wildlife
Photography
by B. "Moose" Peterson

B. "Moose" Peterson

Nikon Guide to

WILDLIFE
PHOTOGRAPHY

Dedication

She's always been my extra set of eyes, she's been there every step of the way to lend her support, encouragement and commitment to making a difference. I would have never made it this far or have a future without my best friend, business partner, and wife, Sharon.

Silver Pixel Press

Acknowledgments

Massing the knowledge to accomplish all I've tackled would not have been possible without the assistance of the dedicated biologists whom I've worked with over the years. No matter how much technical expertise I amassed, without their support I would never been able to put it to use. I want to thank the manufacturers who support has been crucial to my work and this book: David Riley, Michael Mayzel, and Uwe Mummenhoff at LowePro, Gusti Williams at Gusti Blinds, Mark Jacobson at JPI, Mike Kirk at Kirk Enterprises, Anne Laird at A. Laird Photo Accessories, Tony Rose and Jody at Protech, Bryan Geyer at Really Right Stuff, and Mike Hullett and Michael Hess at Saunders. I owe a big thanks to Pete Kolonia, an editor who turned my thoughts to written words that would inspire, educate, and entertain. Lastly, special thanks go to the folks at Nikon who have supported all my efforts and goals for the past decade with advice, equipment, and friendship.

Publisher's Note:
Since this is the first book published under the Silver Pixel Press imprint, I would like to extend sincere thanks to the following people: First of all, to Sharon and "Moose" Peterson who are, without a doubt, two of the nicest people I have ever worked with. To Derek R. Grossmark of Hove Books whose guidance over the past four years has been instrumental in making our book division a success. Thanks also to Michael Robertson for his help, friendship and moral support. And thanks to Steve Hess for forging the great group of people and products known as The Saunders Group. Without his input and high expectations this project would not have been possible.

Marti Saltzman, Silver Pixel Press

Nikon Guide to Wildlife Photography
Volume 1
By B. "Moose" Peterson

First Edition October, 1993

Published by
Silver Pixel Press
Division of The Saunders Group
21 Jet View Drive
Rochester, NY 14624

ISBN 1-883403-06-5

Edited by James Ridgway
Editorial Assistant - David Hess
Production Coordinator - Marti Saltzman
Drawings - Kathryn Pogorzala
Design - Buch und Grafik Design, Günter Herdin, Munich
Design-Assistant - Michaela Schemmerer, Munich
Printed in Germany by Kösel GmbH, Kempten

Contents

Contents

Introduction

Technological advances have made it possible to record biological events on film deemed impossible just a short time ago. I can't think of one species or aspect of behavior beyond the visual reach of today's camera technology! This wasn't true when I started photographing wildlife in 1983. TTL flash technology operated only one flash with a sync of only 1/60 second, autofocus wasn't even in the minds of photographers, and multi-segmented metering was in its crudest form.

Advances in camera technology over the past ten years have opened the doors to thousands of photographers wanting to preserve the great outdoors on film. More nature photographers than ever before are exploring our wild heritage through the probing eye of the camera. These new explorers are our hope of preserving today's natural world for tomorrow's adventurers!

Even with the tremendous innovations in equipment technology and the multitude of photographers owning it, there remains a large void. Many own equipment with features that would solve photographic problems they run into daily, but don't know how to use it. Even the simplest but most vital technique of properly handholding the camera is not utilized, costing hundreds of potentially magnificent images.

An even larger void exists between connecting current technology with animal biology. Getting close physically, not optically, and using optics to isolate and tell a story is the ultimate success, and safeguarding the subject's well-being while capturing images that excite the imagination is the ultimate reward! These voids are unnecessary, as the answers to all your questions are available today.

The Nikon Guide to Wildlife Photography is more than a nature photography book. More than ever, wildlife photographers need to be aware of the camera technology available. Knowing how and when to employ the combination of technology and wildlife biology is the key to safely and successfully getting the photograph on film. This book will open up all the doors to Nikon's technology and show how, where, and when to use it effectively and successfully.

I don't profess to know everything. In fact, my bank of knowledge has had only a few deposits. But from photographing endangered species just in California, I've been able to come to terms with my profession. This has led to the desire to share what I've learned with you, so you can learn from my experiences and make more of your time in the field.

Volume One covers the basics of equipment, making the subject pop, getting close physically, and understanding what makes a photograph successful. The goal of Volume One is to provide the means to combine technology and biology in creating a solid base. It provides the means to go beyond what's discussed and explore in greater depth those aspects of wildlife photography that you find intriguing. It gives you the confidence to take on greater challenges and prepare you for Volume Two: advanced techniques for photographing birds and mammals.

Success in any endeavor requires a strong foundation; biologists refer to this as baseline data. The first chapters of Volume One are just that, baseline data.

In some cases, these are basic techniques. Others are exercises to expand your comprehension in applying new technology to everyday situations. It's only after you have created your own baseline data that you can expand and explore your full photographic potential.

For this series of books to be the most effective, always remember one thing when reading. You MUST take all the information presented, digest it, and retain and use only that information that works for you and your style of photography. Take the rest and *disregard* it.

The captions for the photographic illustrations provide you with the basics of how they were taken, but they don't provide all the answers. You'll find these in the text and by analyzing the photographs yourself. It takes the art of "seeing" to analyze others' photographs or visualize a potential photograph. If that's lacking in your photography, here's an opportunity to start learning. If you're already well down the road to "seeing," here's an opportunity to see how your images can compete with the "professionals."

The captions include a **(C)** or **(P)**. This informs you that the subject was either a captive (C) or park (P) animal. Both are valid forms of wildlife photography, providing great learning and photographic opportunities. No (C) or (P) in the caption means the subject was a wild, free roaming animal. I believe that photographers should always be upfront as to the situation in which the photograph was taken.

Obviously I have enough new information and ideas to write these books, but we all have our own style of communication and that's what photography is all about. My goal is not to create thousands of photographers who mimic my style. I want *you* to communicate the wonders you see in the wilds in *your own words* in your own photographs, so that all the world can marvel at the same moment in nature that caught your imagination! In this way, there will be a natural world to pass on to future generations!

Note: *American model designations for Nikon cameras have been used throughout this book. Many of the cameras I have mentioned have different model numbers in other markets. To assist those living outside of the United States or those who have purchased a camera in other countries, a cross-reference is listed below:*

Opposite page:
Uinta Chipmunk
F4e, 300mm f/2.8 NAF at 2.8, polarized, overcast, tripod (P). Chipmunks can be one of the hardest subjects to photograph, not because they're rare, but quite the opposite. They are seen everywhere so the public wants to see chipmunks up close, cute and most of all cuddly. Successfully communicating these emotions in a photograph takes knowing which lens to use, basic biology, lighting and depth-of-field, thus capturing that universal appeal that the public demands in your photograph.

Nikon Model Designations

USA	International
F3	F3
F4	F4
N90	F90
N8008(s)	F-801(s)
N2020	F-501

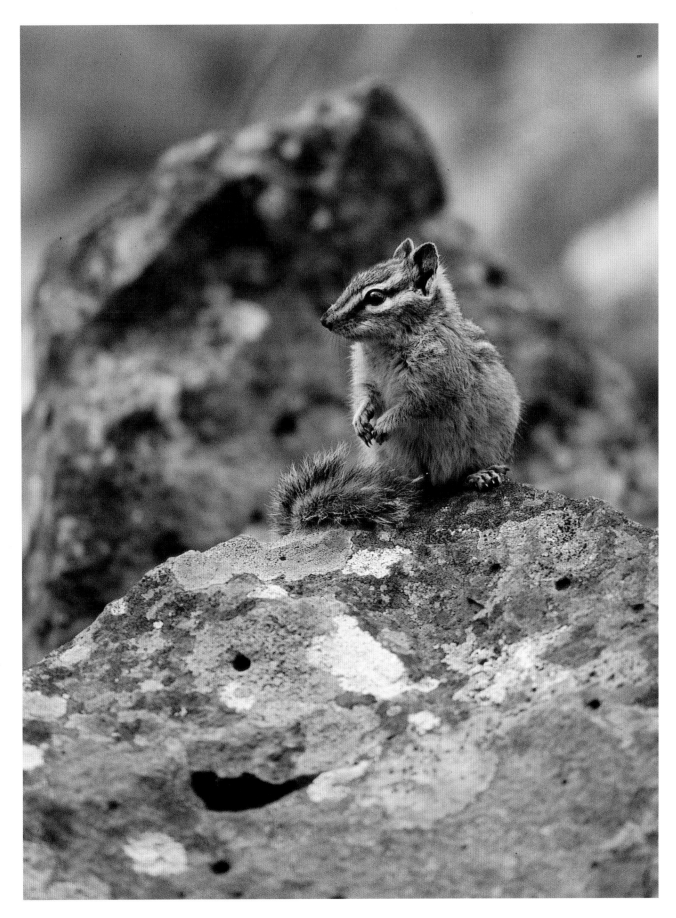

Ground Work -

Chapter I.

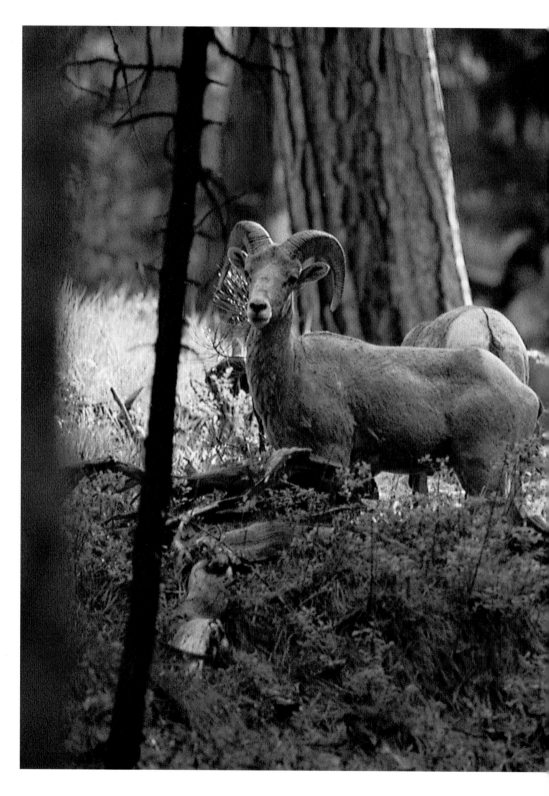

Rocky Mountain Bighorn Sheep, F4e, 300mm f/2.8N AF at f/4, backlight, handheld.